D0368904

GET OUT OF THERE,
CAT!

Kristina Knapp with Sam Stall

RUNNING PRESS
PHILADELPHIA · LONDON

© 2013 by Kristina Knapp
Published by Running Press,
A Member of the Perseus Books Group

All rights reserved under the Pan-American and International Copyright Conventions

Printed in China

Books published by Running Press are available at special discounts for bulk purchases in the United States by corporations, institutions, and other organizations. For more information, please contact the Special Markets Department at the Perseus Books Group, 2300 Chestnut Street, Suite 200, Philadelphia, PA 19103, or call (800) 810-4145, ext. 5000, or e-mail special.markets@perseusbooks.com.

ISBN 978-0-7624-4678-0
Library of Congress Control Number: 2012944537

E-book ISBN 978-0-7624-4823-4

9 8 7 6 5 4 3 2
Digit on the right indicates the number of this printing

Cover and interior design by Robert Williams
Edited by Jordana Tusman
Typography: Archer and Univers

Running Press Book Publishers
2300 Chestnut Street
Philadelphia, PA 19103-4371

Visit us on the web!
www.runningpress.com

CONTENTS

INTRODUCTION

What drives cats to sit (and jump, and climb, and sleep) in and on anything they can possibly find? Whatever it may be, our feline friends know it, and we don't. Our warm, clean laundry; empty boxes intended for the trash; and important and irreplaceable documents—all have fallen victim to our cats' desire to take over anything and everything we own.

Luckily for these pesky little creatures, they somehow manage to appear irresistibly adorable in the process of ruining our every possession. It is from these hilarious and infuriating moments that the Get Out of There, Cat! (GOOTC) blog was born—a collection of photos from cat owners around the world who struggle daily with a cat (or cats) who just don't seem to get the hint.

From sitting on our hands while we're trying to type, to yowling outside our bedroom doors all night, let's face it: cats rule our world. And while we don't want in any way to encourage this unacceptable behavior, we still can't help but to fawn

over them when they're in all their annoying yet oh-so-adorable glory. After all, why else would we spend exorbitant amounts of money on their holistic food, organic catnip, and recyclable scratch pads? Forget dogs; cats are our best friends—even if they do occasionally try to kill us by using us as launch pads from which to pounce on the laser pointer light.

We, therefore, would like to present for your viewing and reading pleasure the official *Get Out of There, Cat!* book, featuring some of our most favorite submissions from the blog, as well as never-before-seen photos and captions. To see more, visit us at *getoutoftherecat.tumblr.com*; follow us on Twitter at *@getoutofthercat* and "like" our page on Facebook. Something tells me that we will not be running out of cat photos anytime soon.

DISASTERS WAITING TO HAPPEN
(CAT, YOU ARE RUINING MY LIFE.)

Sometimes it really seems like our cats have it out for us. You feed them, care for them, let them scratch up your furniture, and all you get in return is Kitty trying to trip you as you carry a stack of laundry down the stairs, or knock over the most expensive thing in your house that you purposely placed out of her reach. The truth is, cats are maniacal little critters intent on our destruction, and this chapter is dedicated to exposing them for what they truly are. Just don't let your cat get a peek at any of these photos; we wouldn't want her getting any more bright ideas.

For the last time, cat,
I can't smuggle you to Vegas inside my carry-on.

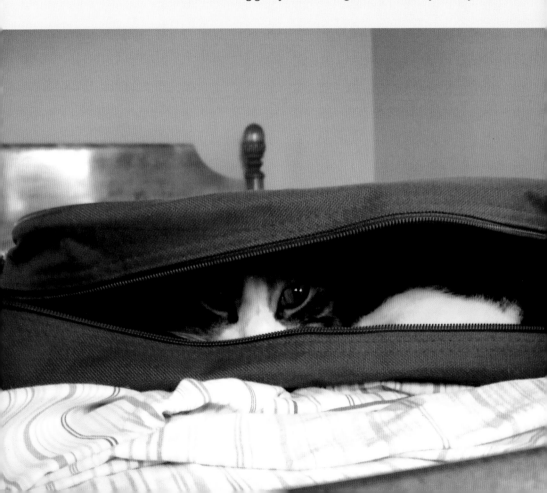

Get out of there, cat. I don't know where you found a feline-size tank, but I'm not intimidated. You are not a soldier. You are a cat.

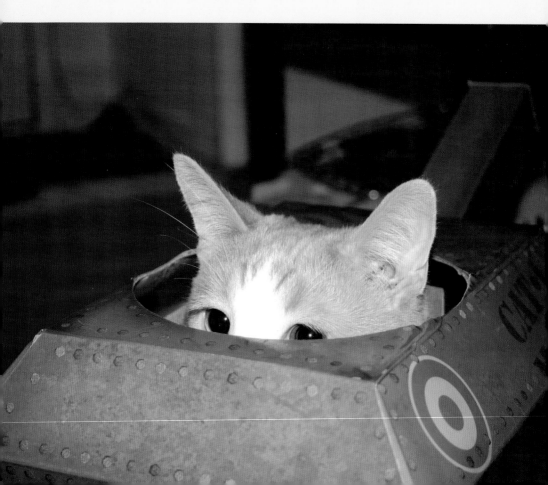

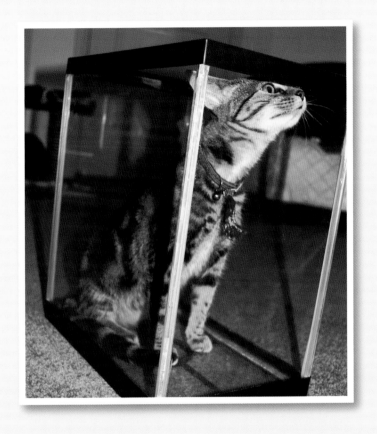

No, cat. I'm not refilling the aquarium and buying more fish.
Not after what you did to the last batch.

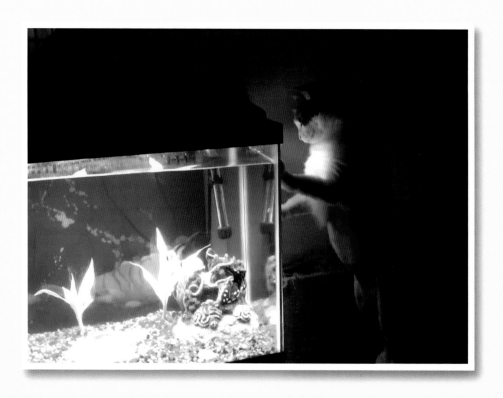

Get away from there, cat. It's an aquarium, not a snack bar.

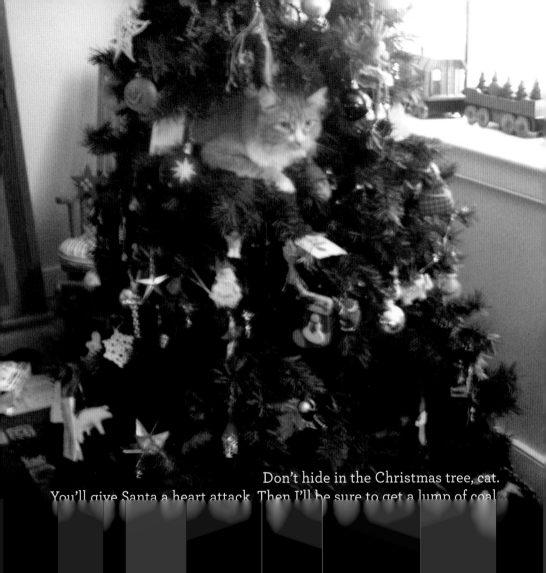

Don't hide in the Christmas tree, cat.
You'll give Santa a heart attack. Then I'll be sure to get a lump of coal...

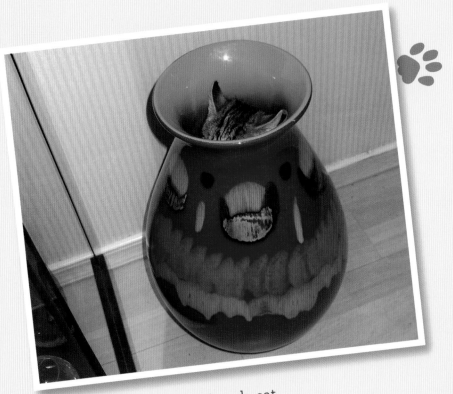

You're terrible at hide-and-seek, cat.
Everyone knows you're hiding in that urn.

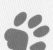

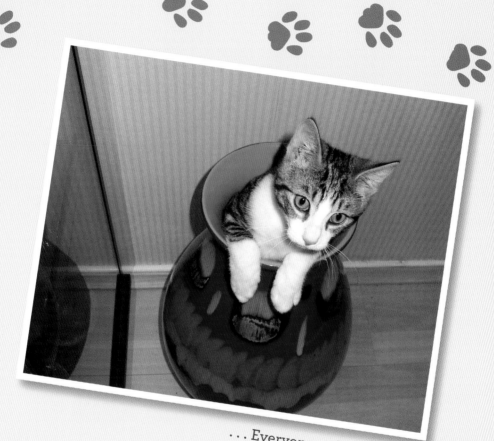

. . . Everyone *still* knows, cat.

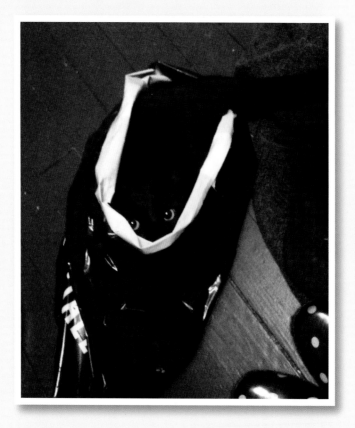

Quit looking for goodies, cat. I went shopping for me, not for you.

Put that down and get off the couch, cat.
You're a mess. Have you even looked for a job this week?

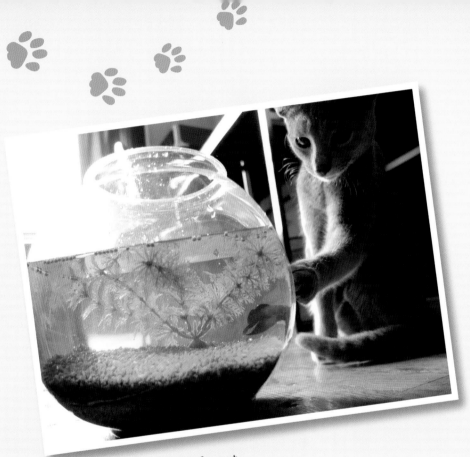

Get away from that fish, cat.

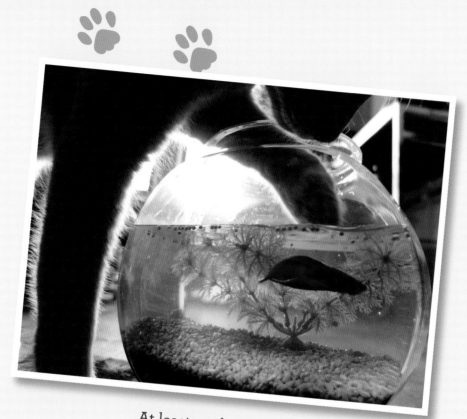

At least wash your paws when you're done.

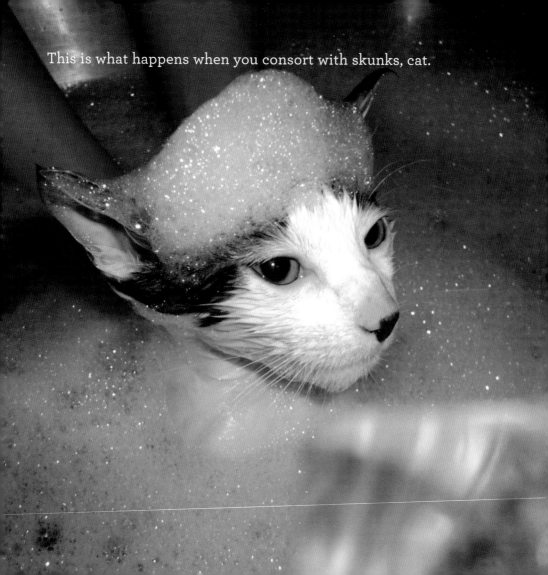

This is what happens when you consort with skunks, cat.

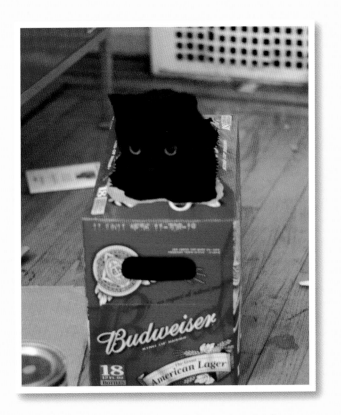

Get out of there, cat. The party's over.
You don't have to go home, but you can't stay here.

YOU FOUND HER *WHERE?*
(AND HOW DID SHE GET THERE IN THE FIRST PLACE?)

The heart of GOOTC is, of course, our cats' penchant for getting into places they shouldn't. It's as if they have an inner compass that directs them to the most inconvenient places. You'd think your cat had swallowed a magnet by the way she's attracted to the refrigerator. Of course, we can often only speculate as to how they even got into these situations to begin with. Here, you'll see some of the stranger places we've found our cats over the years.

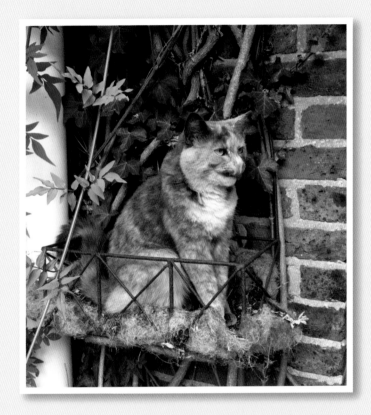

Why are you sitting in the flower box, cat,
and what did you do with the peonies?

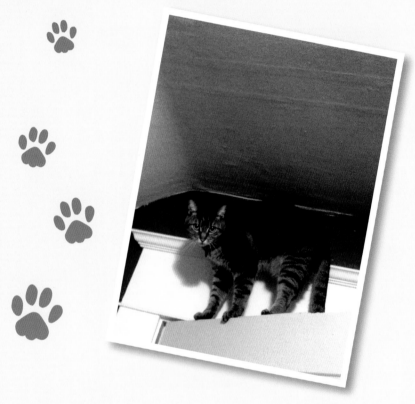

Don't jump on me, cat.
Your mountain lion impression is spot-on, but I'm sick of being ambushed.

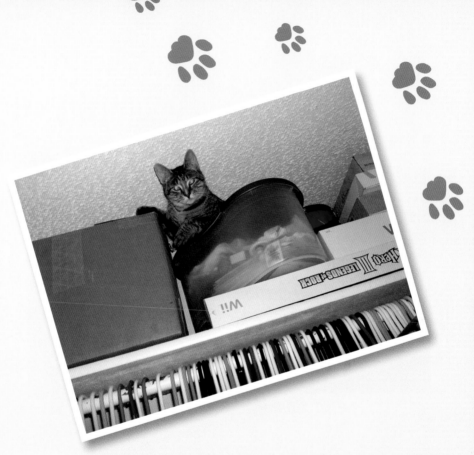

Time to go into winter storage, cat.
You can come out again next November.

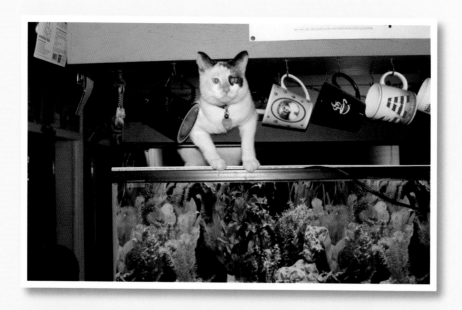

You're the goofiest-looking mug in this house, cat.
And that's saying something.

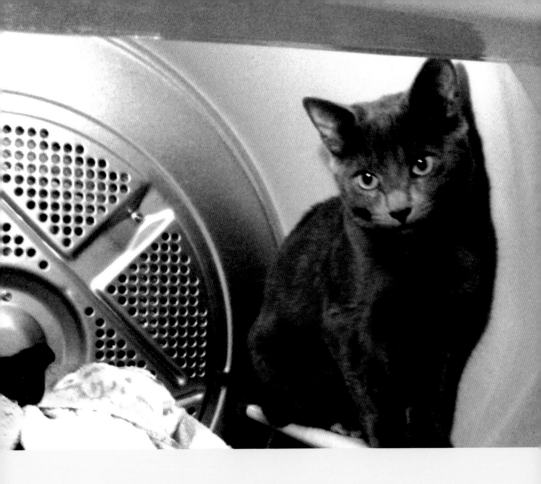

Get out of there, cat. You might shrink.

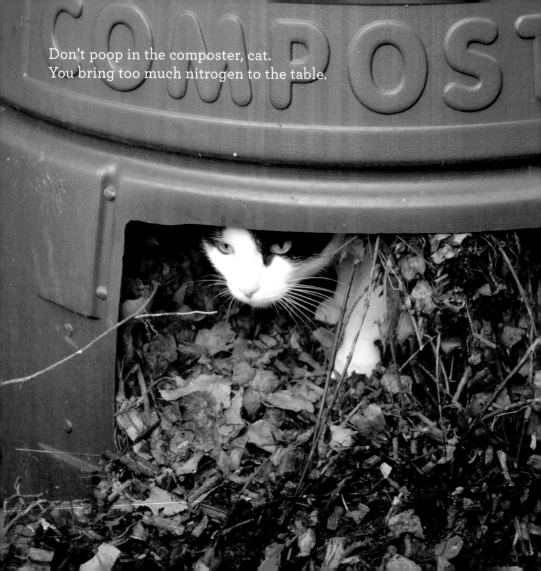

Don't poop in the composter, cat.
You bring too much nitrogen to the table.

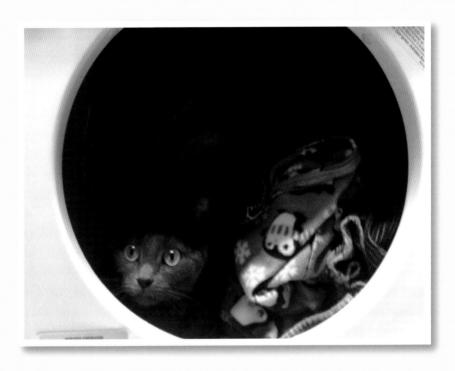

No more dryer rides, cat. You're overloading the lint trap.

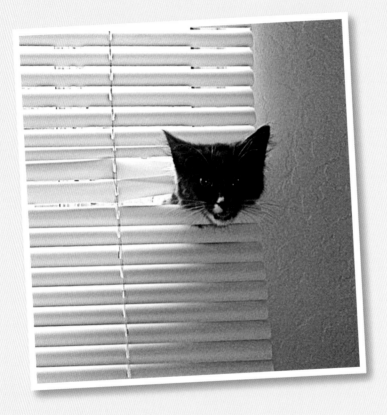

Serves you right, cat.
The only thing that belongs behind the blinds is the window.

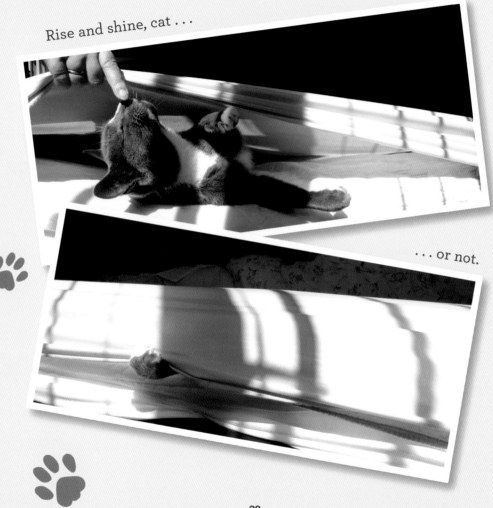

Rise and shine, cat . . .

. . . or not.

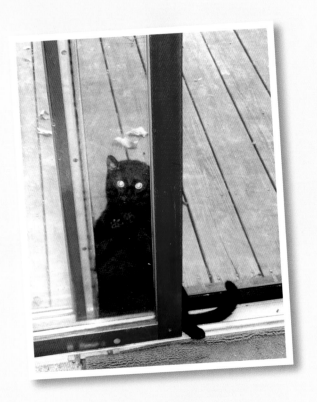

Sorry you failed the screening test, cat.

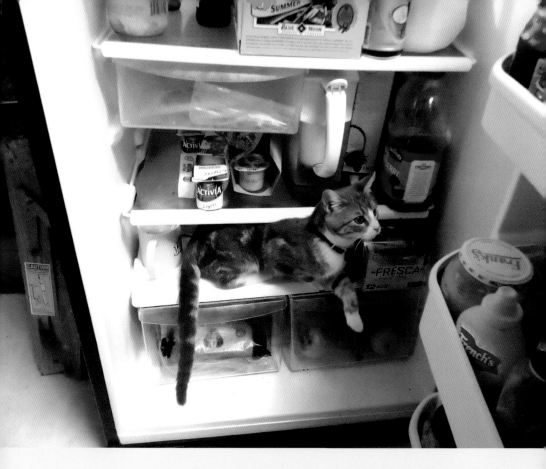

Sitting in the fridge won't help you, cat.
You're already spoiled and rotten.

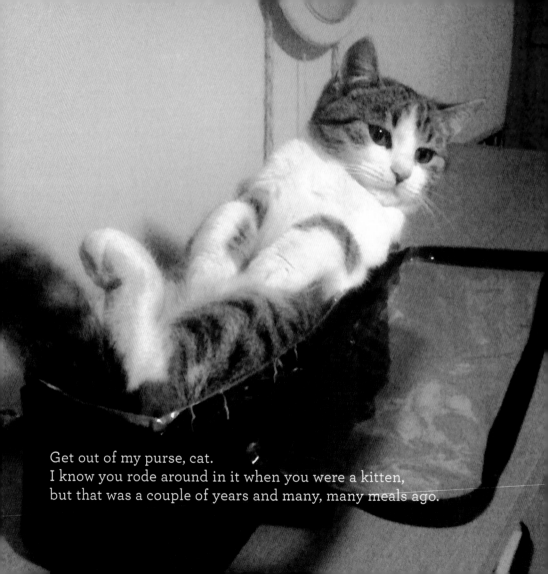

Get out of my purse, cat.
I know you rode around in it when you were a kitten,
but that was a couple of years and many, many meals ago.

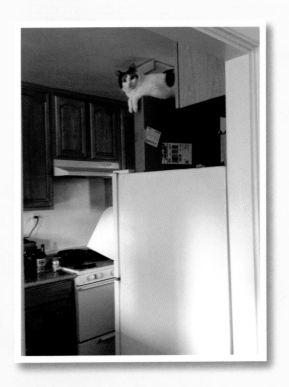

Never mind how you got the
delivery box up there, cat. How did you sign for it?

SENDING A MESSAGE
(DON'T YOU THINK TEXTING WOULD BE EASIER?)

Cats don't speak English, or at least they're not supposed to. But that doesn't mean they don't want to communicate with us. Whether they want more food, more toys, more food, or playtime, they're going to let you know it. Sometimes, however, it can take us a second to interpret what it is exactly they're trying to tell us . . . if we can even figure it out at all. See if you can determine what these cats are trying to say. Then, guess again.

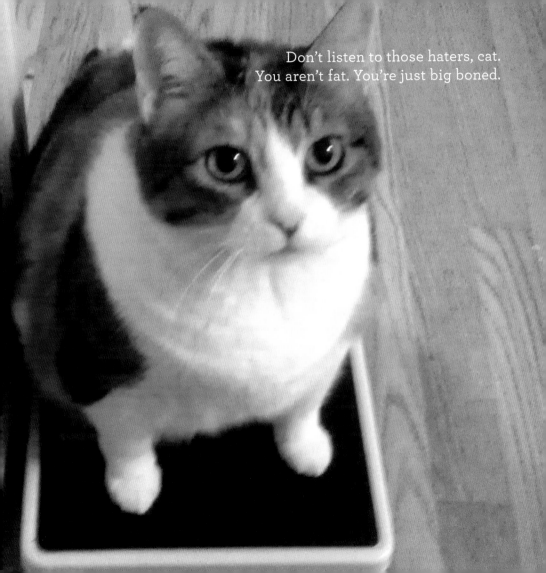
Don't listen to those haters, cat. You aren't fat. You're just big boned.

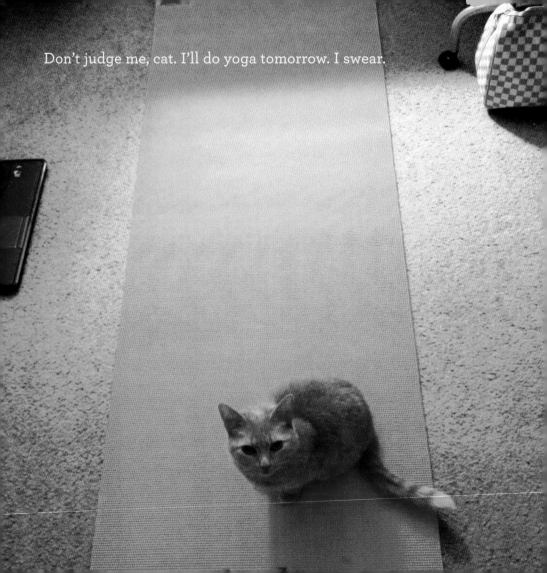

Don't judge me, cat. I'll do yoga tomorrow. I swear.

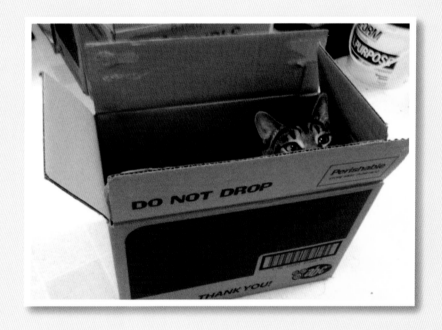

Stop hiding, cat. The Girl Scouts are here to discuss your bill.

Don't try to look so innocent, cat.
This caper's got your paw prints all over it.

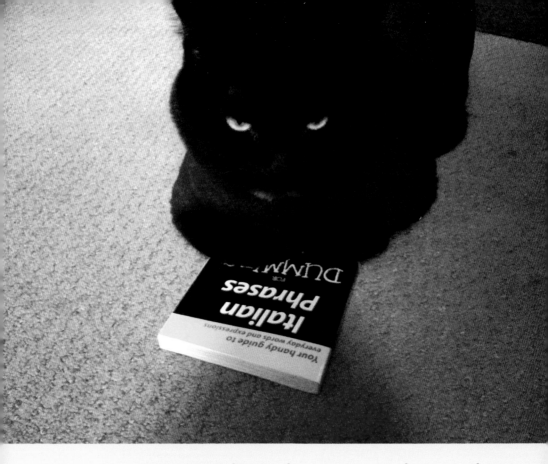

Stop trying to learn Italian, cat. It won't change anything.
I'm going to Italy, and you're going to stay with my parents. Accept it.

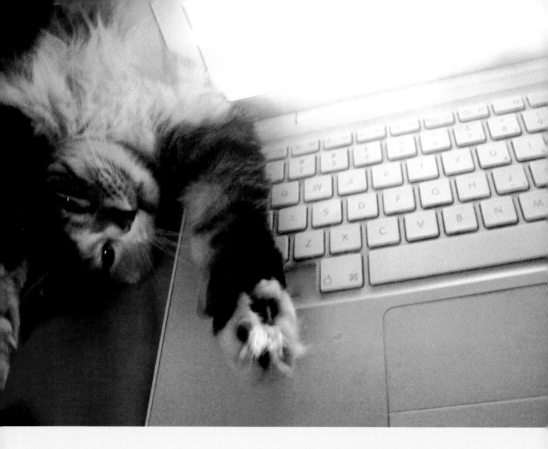

No, I'm not taking you to Starbucks so you can get better WiFi reception. You're a cat. You do nothing. Your Facebook page doesn't require constant updates.

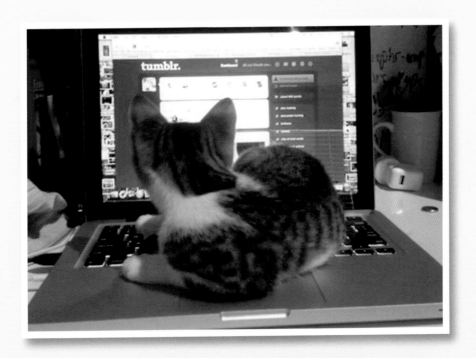

Yes, cat, I know that the video of you in the dryer has gotten 150,000 views. No, I'm not jealous that you're more tumblr-famous than I am. Fine, maybe a little.

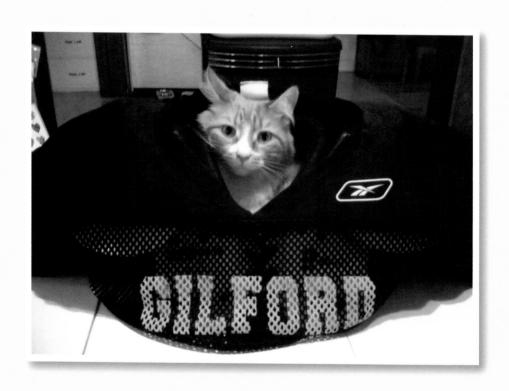

So that's why you always
smell like sweat and Gatorade, cat.

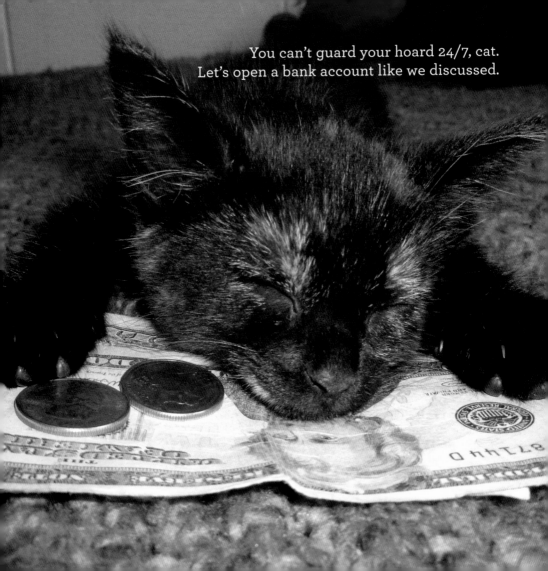

You can't guard your hoard 24/7, cat.
Let's open a bank account like we discussed.

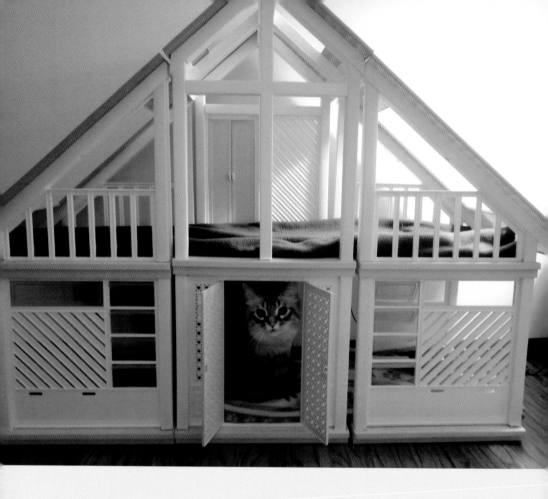

Forget it, cat. You'll never get financing for a place that big.

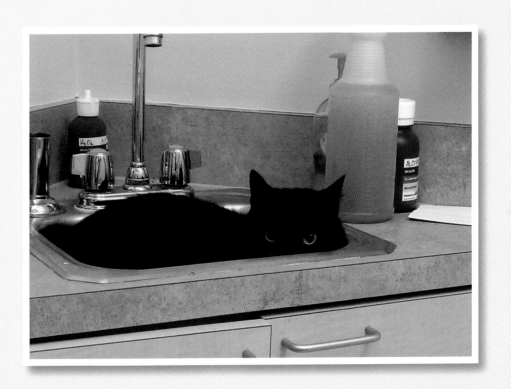

Go crash in the laundry room sink, cat.
It's roomier. Also, I need to wash my hands.

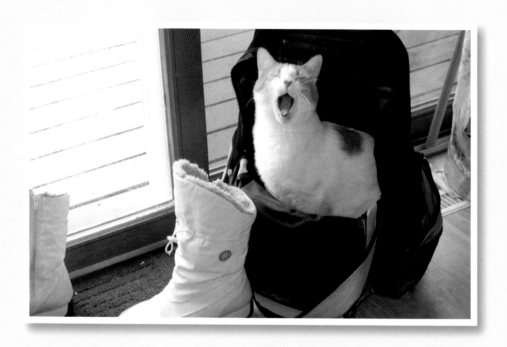

Quit dissing my snow boots, cat. I got them because they match you.

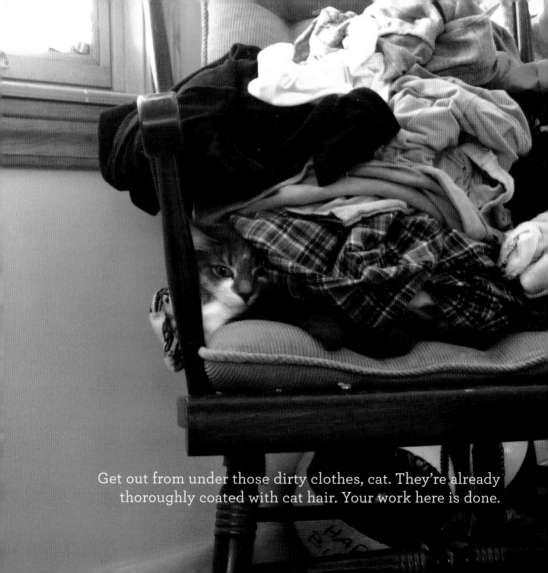

Get out from under those dirty clothes, cat. They're already thoroughly coated with cat hair. Your work here is done.

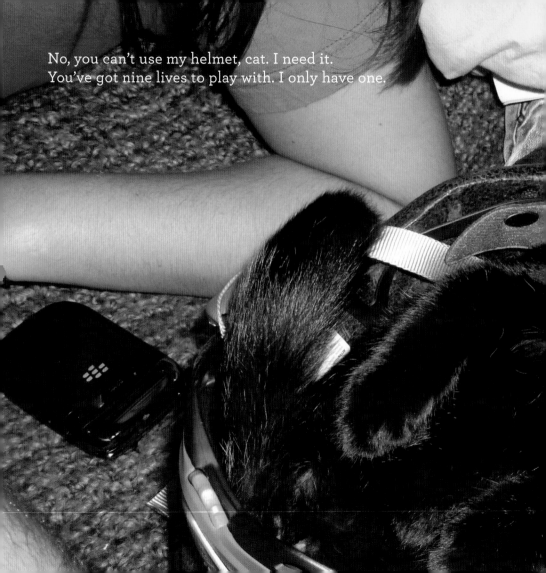

No, you can't use my helmet, cat. I need it.
You've got nine lives to play with. I only have one.

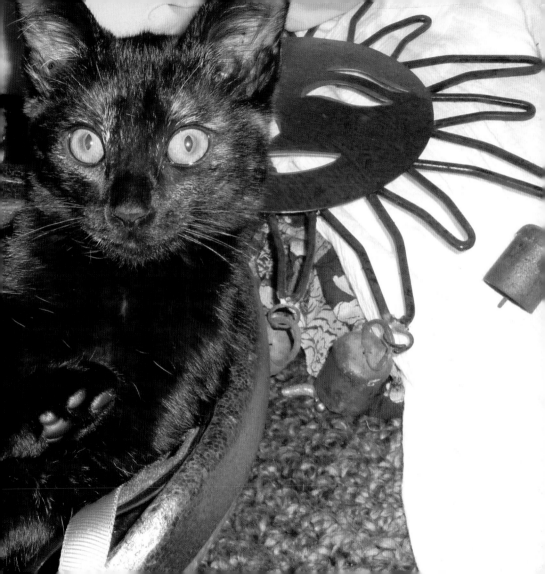

TOO CUTE

(SERIOUSLY, IT'S TOO CUTE. DIAL IT BACK A LITTLE.)

To be honest, our cats don't serve much of a practical purpose except for giving us something cute to look at during those boring periods in between sleep and TV shows. It must be something about the pink noses, wide eyes, and twitchy ears. Some cats seem to specialize in being over-the-top cute; that's why I keep so many cameras around my house. Now if I could just get them to stop playing hockey with my hair ties....

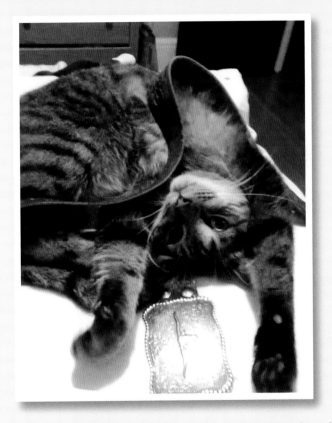

No, I won't wear that rodeo belt, cat. The Urban Cowboy look went out decades ago. You'd know that if you glanced at a fashion magazine occasionally—instead of just sleeping on them.

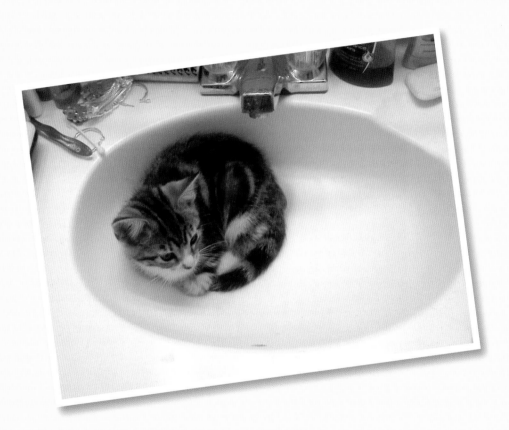

You're evicted from the sink, cat. My need to brush
my teeth trumps your desire to nap anytime, anywhere.

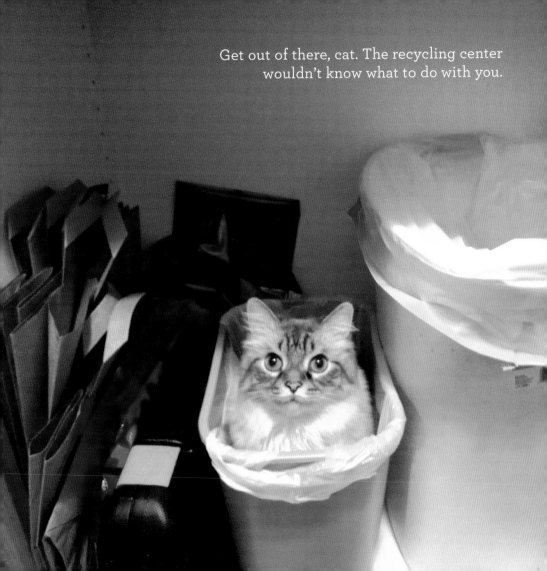

Get out of there, cat. The recycling center wouldn't know what to do with you.

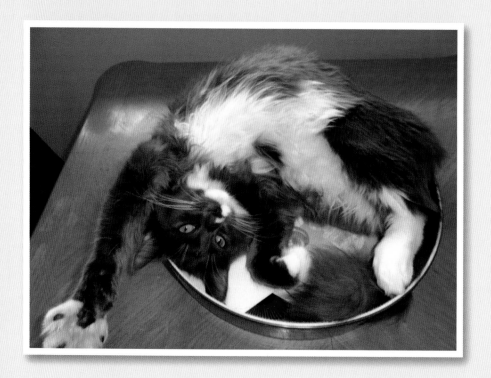

You're a party platter of fun with a side order of crazy, cat.

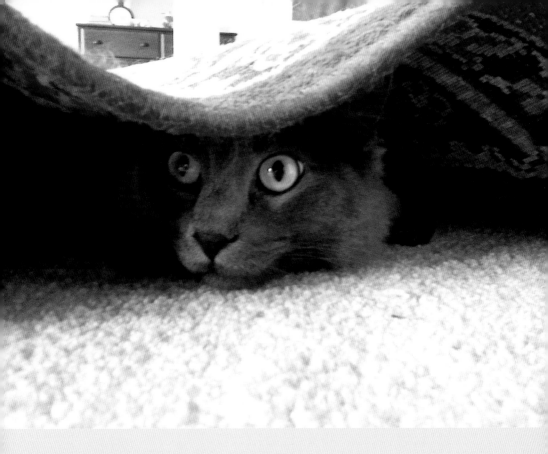

Get out from under there, cat. I've told you a million times, dust bunnies aren't alive, and they certainly aren't edible.

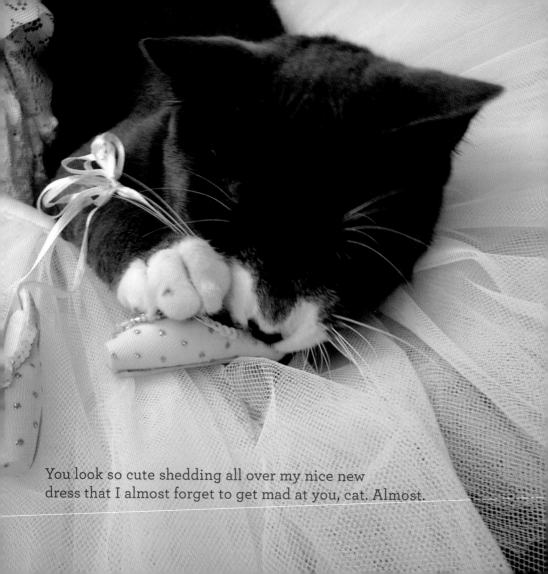

You look so cute shedding all over my nice new dress that I almost forget to get mad at you, cat. Almost.

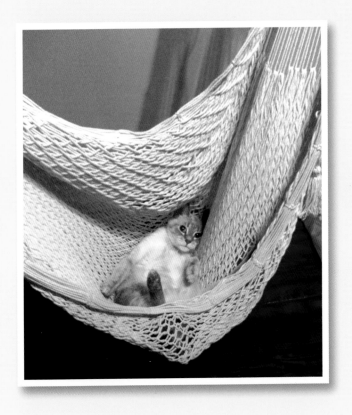

Get out of there, cat. Gilligan wants his hammock back.

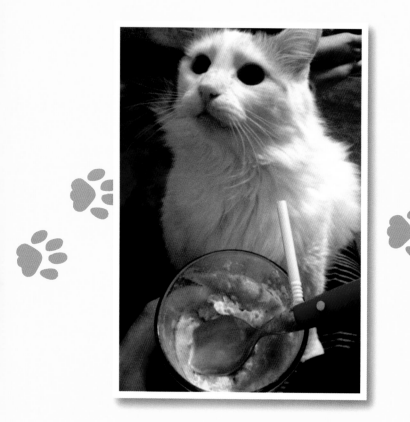
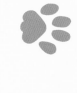

None for you, cat.
I don't care how sad you look or how impossibly large your pupils get.

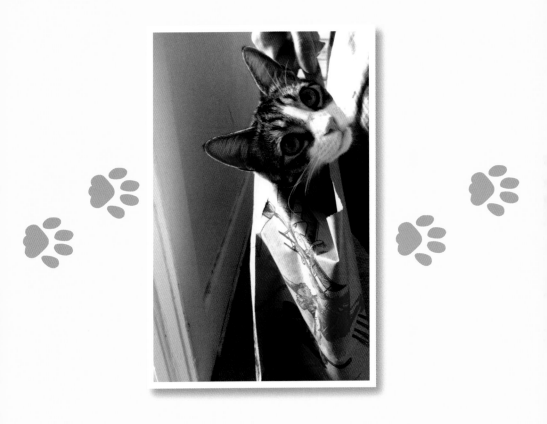

Get out of that bag, cat. You can't go to the grocery store anymore.
Not after the Great Meat Counter Incident of '09.

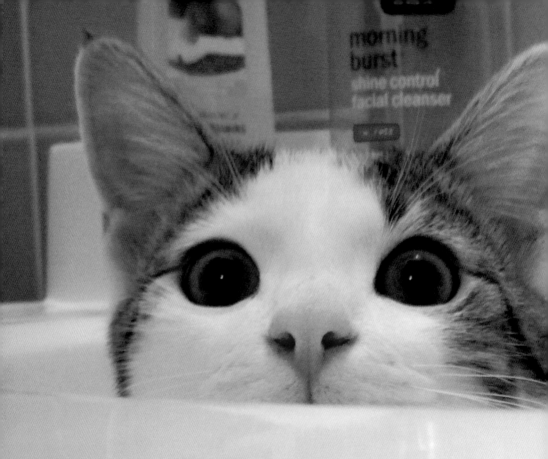

Don't look so shocked, cat. If you insist on sleeping in the bathroom sink, then I insist on peeing in front of you.

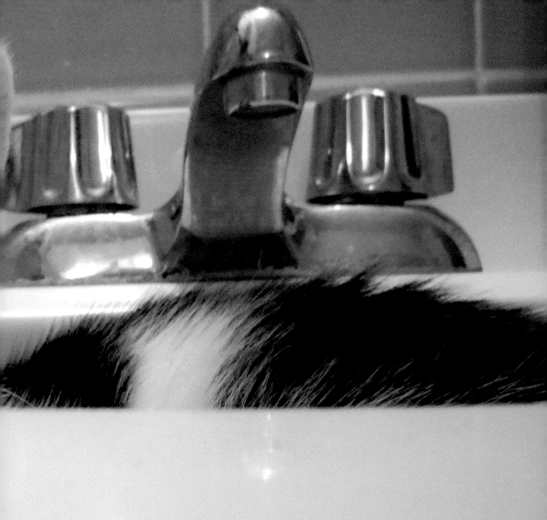

"CATNAP" IS AN INAPPROPRIATE TERM
(IT'S MORE LIKE A CAT COMA.)

What do cats love to do most (besides eat)? Conk out in the most inconvenient places possible. Sometimes it's a mystery as to why our cats would even choose these uncomfortable spots. Oh well, sleep and let sleep, I say—except when she's sleeping on my clean clothes. In that case, get off!

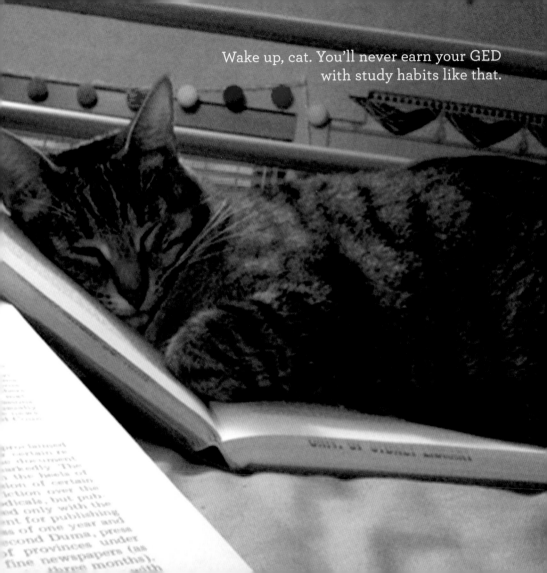

Wake up, cat. You'll never earn your GED
with study habits like that.

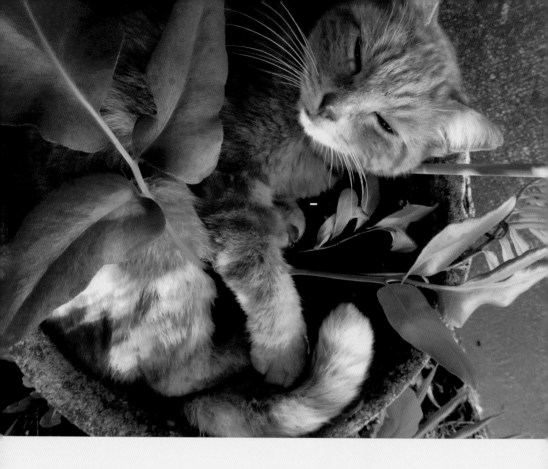

Lay off of the pot, cat.
Otherwise, the dog and I will have to organize an intervention.

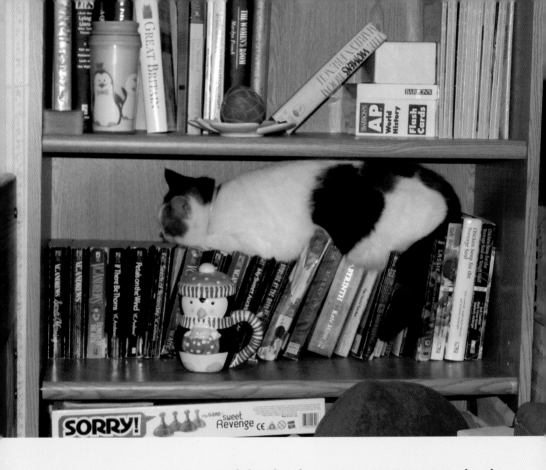

Get out of that bookcase, cat. You are not a book.
You're much, much harder to read.

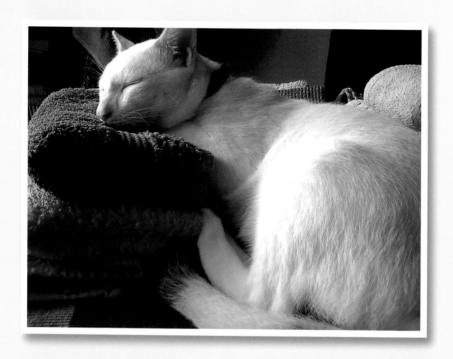

Why not lie on some white towels, cat?
At least when you shed on those it isn't as obvious.

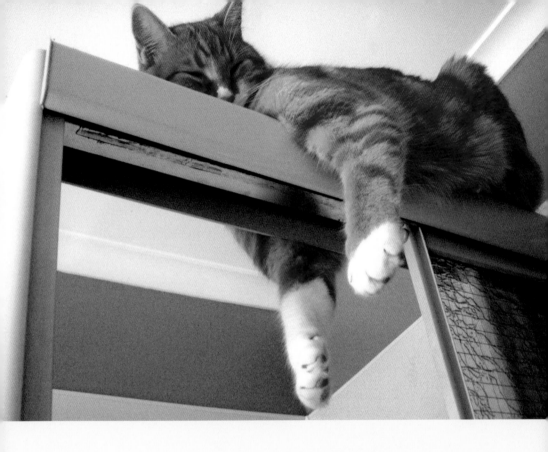

Jump down from the shower door, cat. But before you do,
please bat down those cobwebs in the corner.

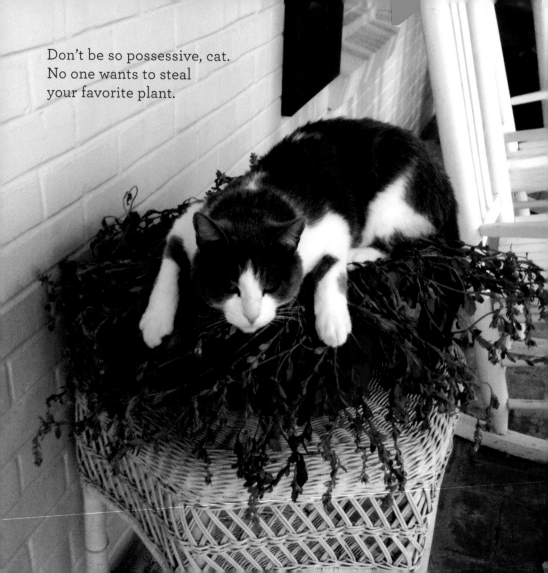

Don't be so possessive, cat.
No one wants to steal
your favorite plant.

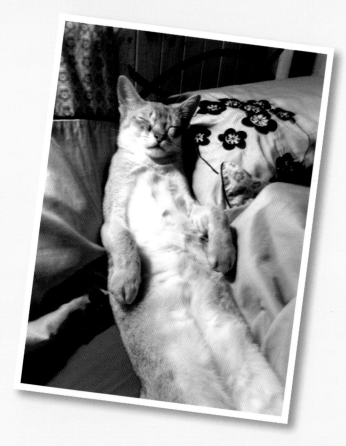

You're just sleeping, aren't you, cat?
Seriously, flick a paw or something. You're freaking us out.

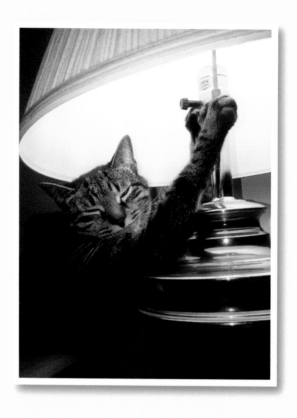

Quit turning out the lights, cat. Eight o'clock is
too early for bed. Especially eight o'clock in the morning.

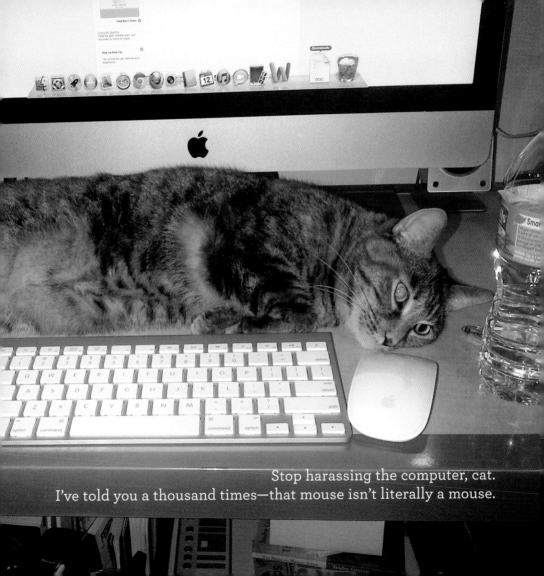

Stop harassing the computer, cat.
I've told you a thousand times—that mouse isn't literally a mouse.

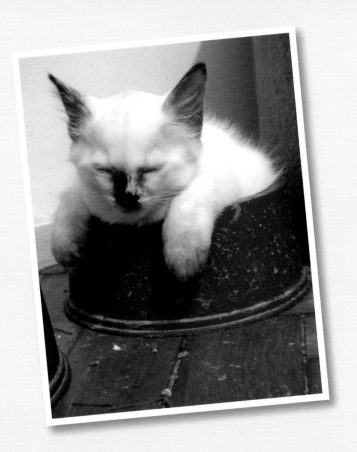

Get out of there, cat.
No wonder your butt smells like Purina Cat Chow.

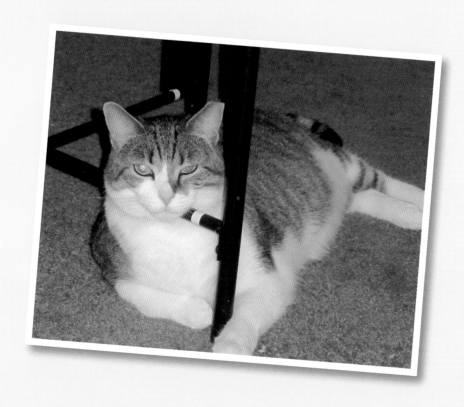

Don't be so lazy, cat. I refuse to believe
you can't even raise your head without assistance.

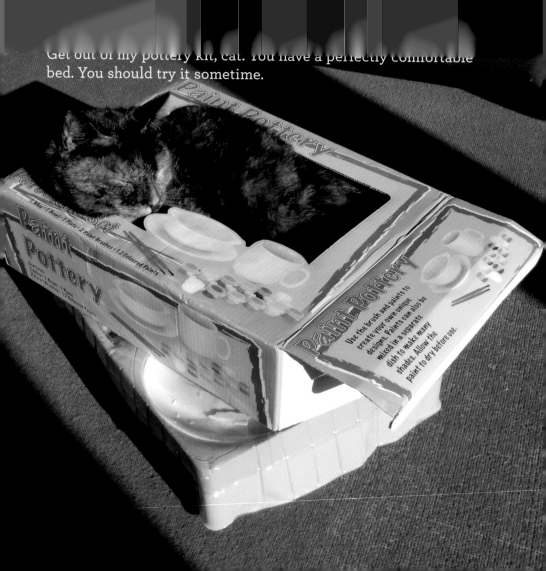

Get out of my pottery kit, cat. You have a perfectly comfortable bed. You should try it sometime.

Stay right where you are, cat.
You look so comfy that I think I'll join you.

Leave my day planner alone, cat. I've fed you every day at six p.m. for the last six years. I don't need you to write me reminders.

JUST PLAIN WRONG
(*I EXPECTED BETTER OF YOU, CAT.*)

Are cats capable of being funny? Here are a few photos that scream: "YES!"

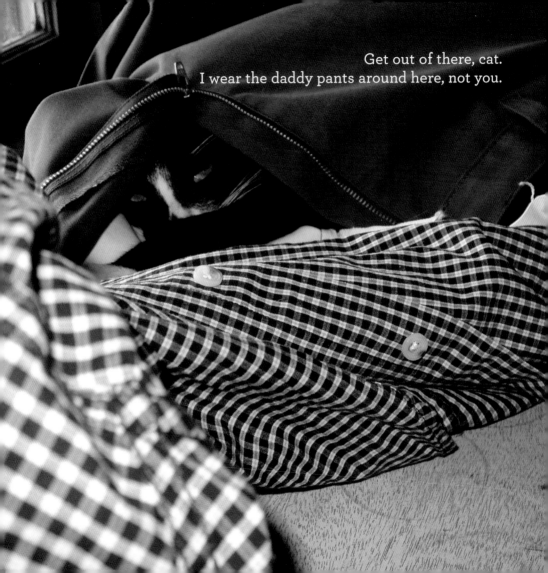

Get out of there, cat.
I wear the daddy pants around here, not you.

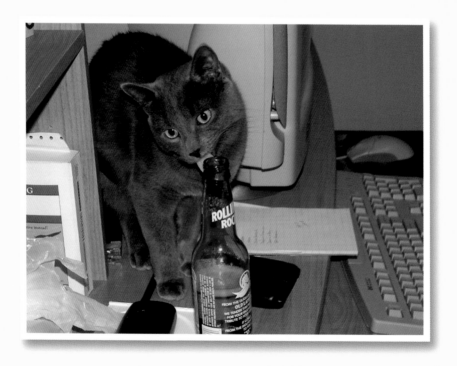

That one's all yours, cat.

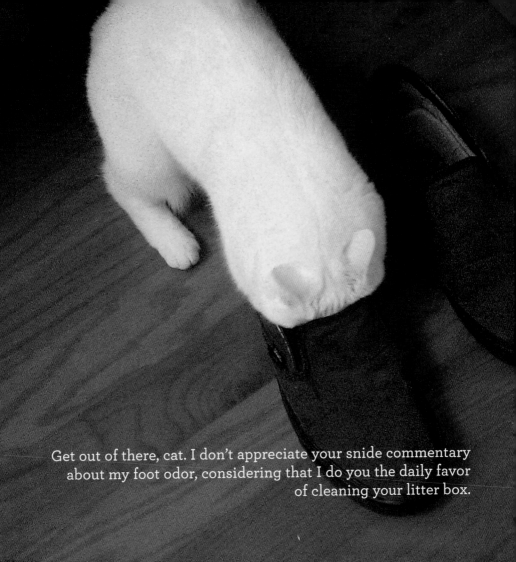

Get out of there, cat. I don't appreciate your snide commentary
about my foot odor, considering that I do you the daily favor
of cleaning your litter box.

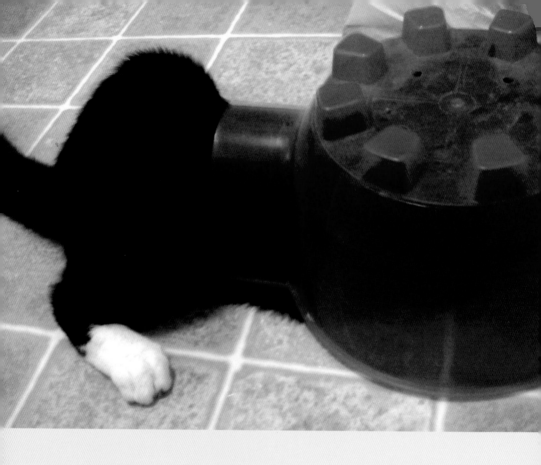

You can't get in, cat.
Your heart says yes, but your anatomy says no.

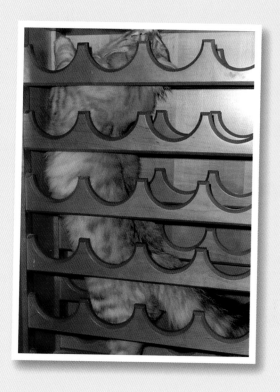

Leave the wine rack alone, cat. You're the reason we have to keep the good stuff in the basement—under lock and key.

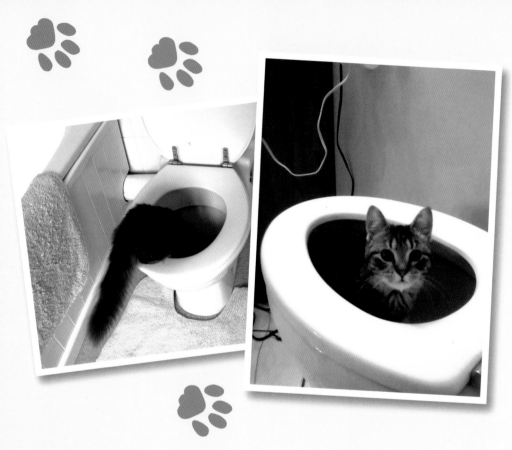

The dead goldfish I flushed away last week won't ever come back, cat. Accept it and move on.

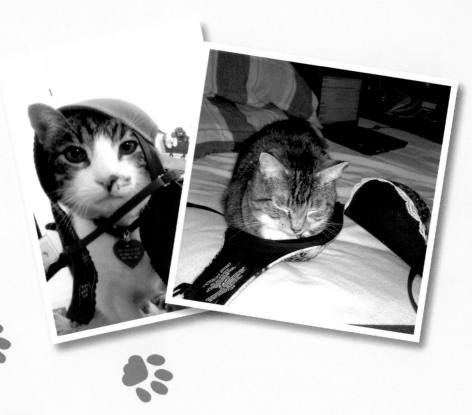

Stop that silliness, cats. Your heads may be perfect C's,
but your brains are a pair of sad little A's.

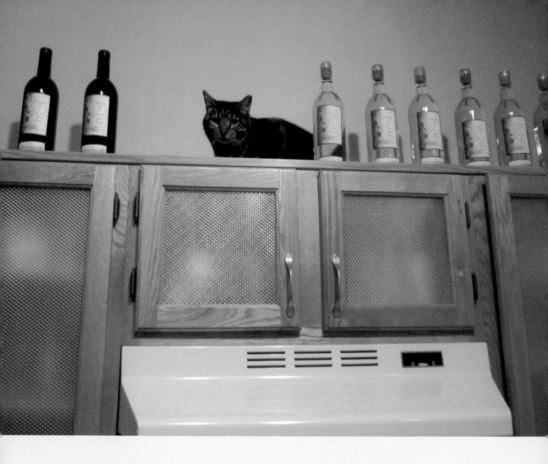

Off that ledge, cat.
You've already taken two Rieslings and a nice Chianti.

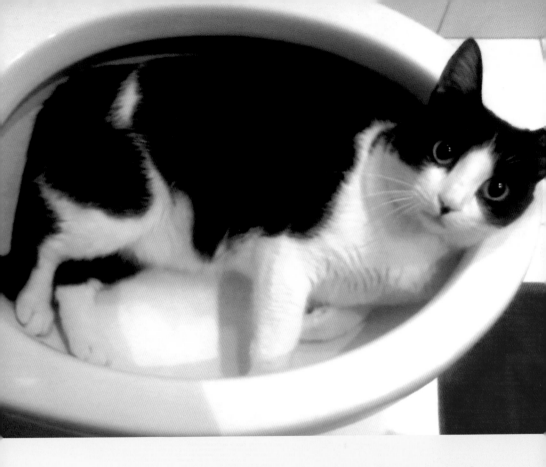

Just because you can sleep in something
doesn't mean you should, cat.

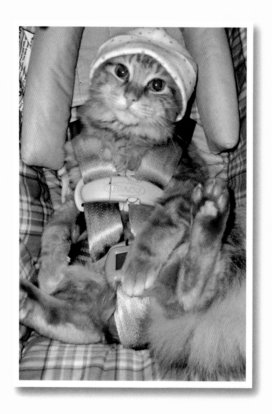

You won't lose any lives on *my* watch, cat.

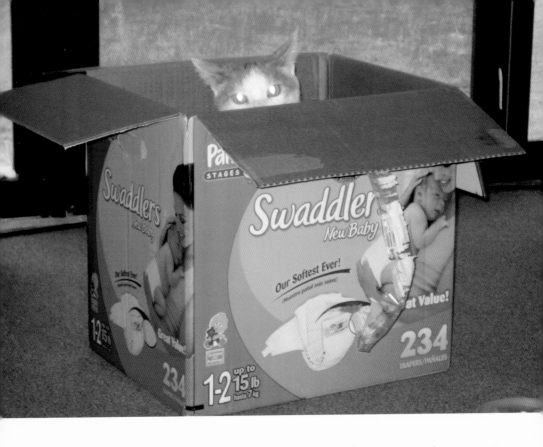

What are you doing, cat?
It better not be what it looks like you're doing.
You have a perfectly good litter box for that.

YOU'RE ON YOUR OWN ON THIS ONE, CAT
(JUST GRIN AND BEAR IT.)

In the course of her escapades, every cat will at some point get herself into a situation she can't get out of. Of course, when she does, she just gives you that expectant look that says, "Well? What are you waiting for? Help me out of here!" So we drop everything we're doing just to help her—but not before taking a picture.

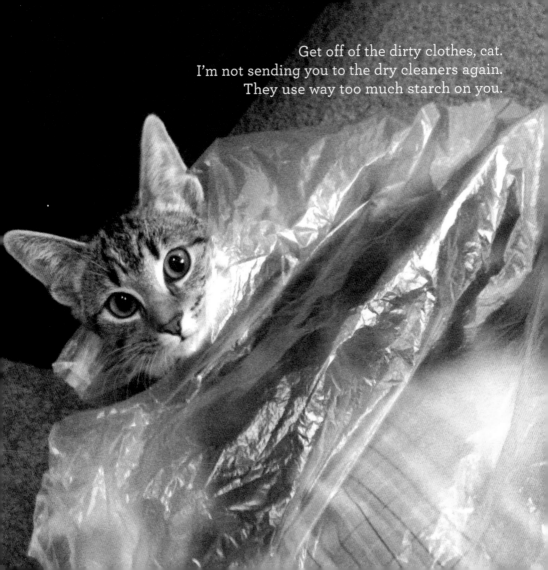

Get off of the dirty clothes, cat.
I'm not sending you to the dry cleaners again.
They use way too much starch on you.

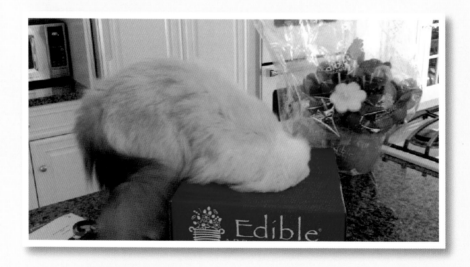

Quit searching the box, cat. It's just fruit.

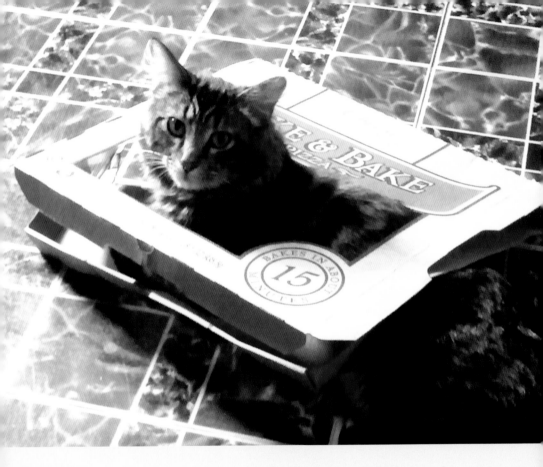

Get out of that pizza box, cat.
Then tell us where our breadsticks went.

Come out, cat.
Then explain how you got under there in the first place.

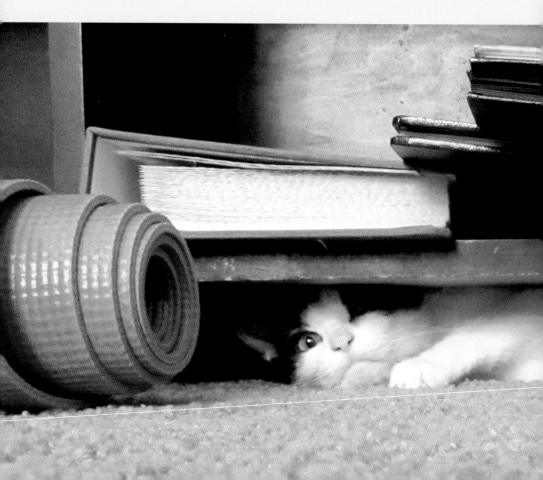

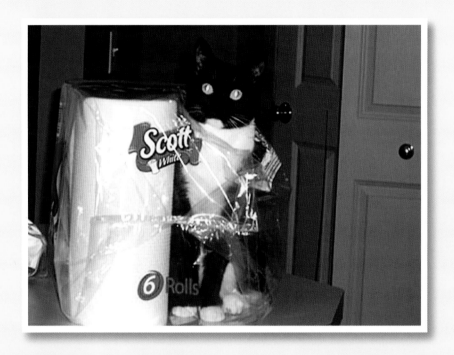

You're not a paper towel, cat. Yes, you're usually fluffy and soft, but you can get quite scratchy when exposed to water.

Don't get out of there, cat.
Just wait quietly while we fetch a crowbar and some Vaseline.

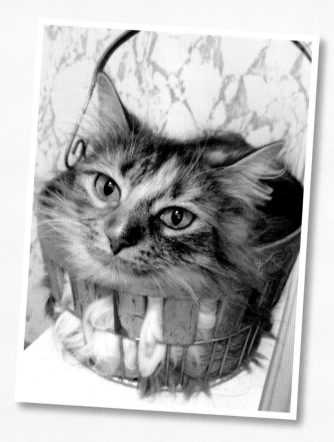

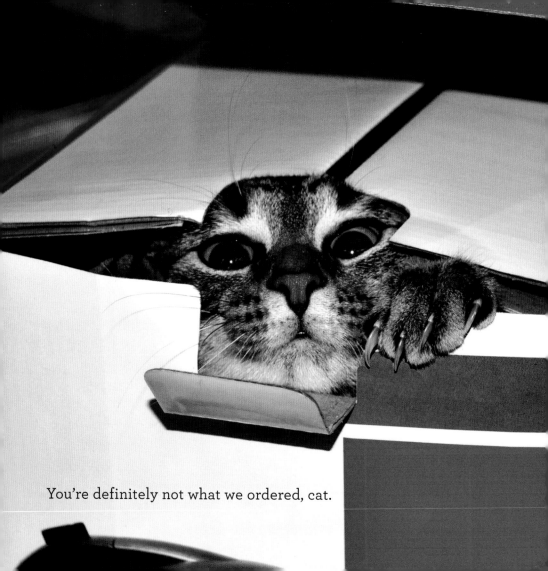

You're definitely not what we ordered, cat.

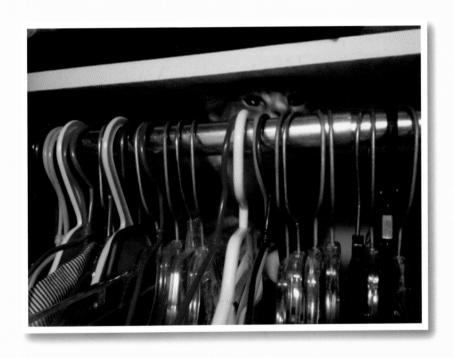

Get out of there, cat.
Though we appreciate your ambition, you really don't need to get cat hair on every single one of our garments—everywhere.

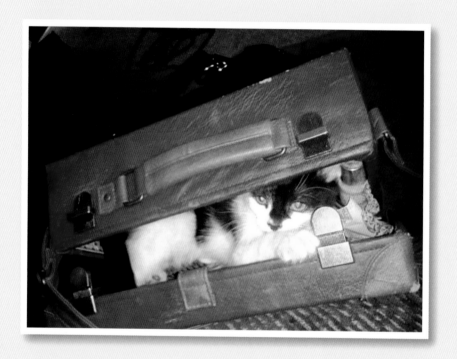

Forget it, cat.
You'd never make it through airport security.

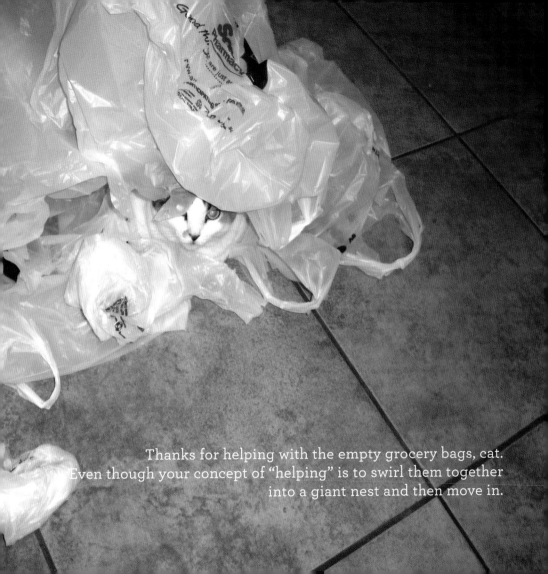

Thanks for helping with the empty grocery bags, cat.
Even though your concept of "helping" is to swirl them together
into a giant nest and then move in.

CATS AND THEIR FRIENDS

(RATHER, CATS AND THE CREATURES THEY HATE SLIGHTLY LESS THAN YOU.)

Every good superhero needs a sidekick the same way that every villain needs an accomplice. Do your cats like to throw up in your shoes? Chances are they fall into the second group.

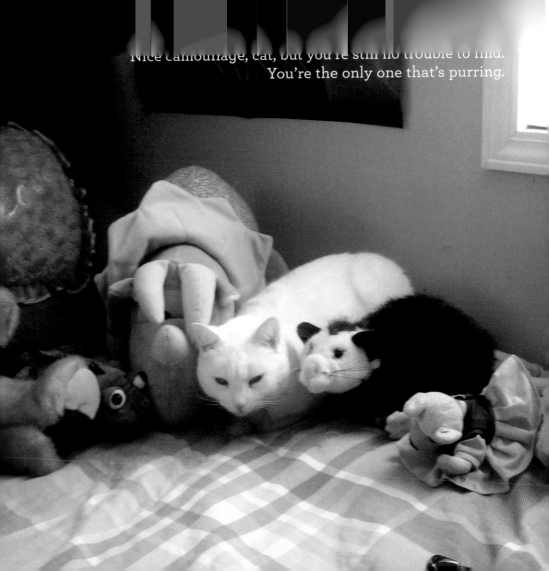

Nice camouflage, cat, but you're still no trouble to find.
You're the only one that's purring.

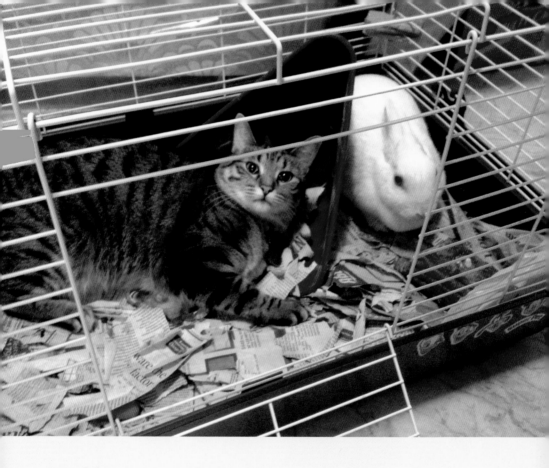

Out of that cage, cat. The bunny wants you to leave.
He's just too terrified to say anything.

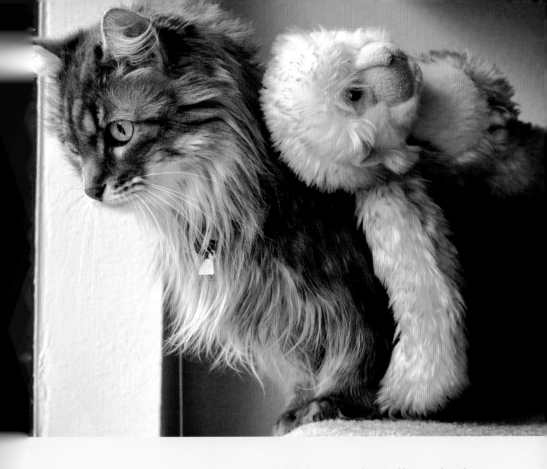

Take that monkey off your back, cat.
If something's troubling you, just tell us. No need for metaphors.

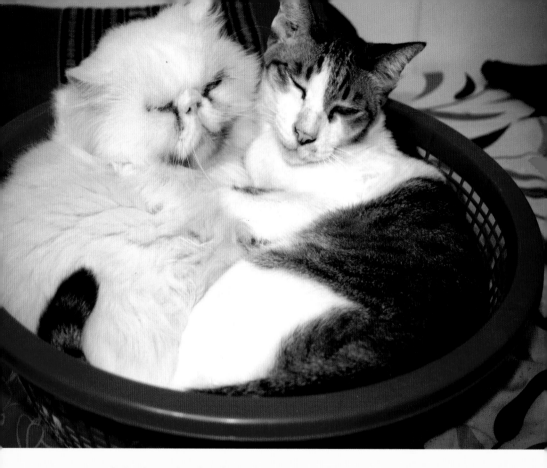

Get out of the laundry basket, cats.
You have an entire house to sleep in. No reason for crowding.

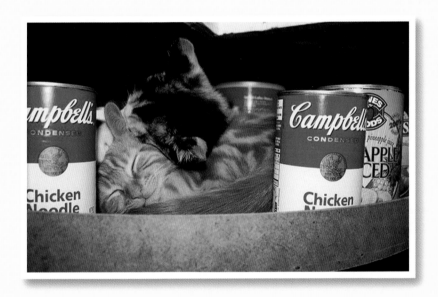

Get out of there, cats. I know you both love chicken noodle soup,
but you don't have to build your lives around it.

We're not returning her for a refund, cat. Though we're quite impressed that you somehow got her back into her original packaging.

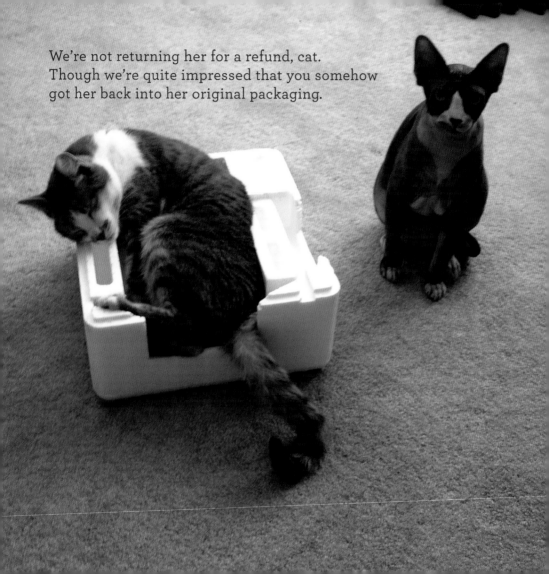

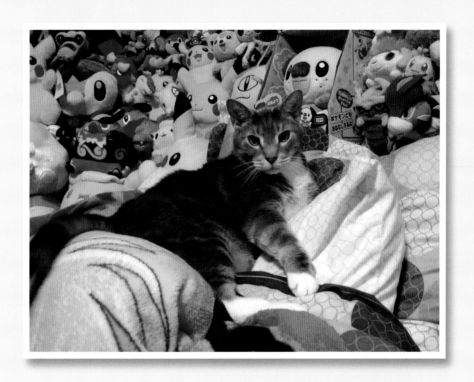

No more eBay, cat. You've officially
crossed the line between hobby and obsession.

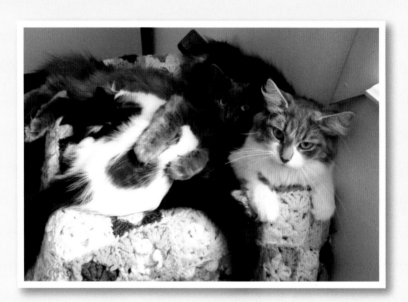

Yes, cat, your friends can sleep over.
No, I'm not ordering them an anchovy pizza.

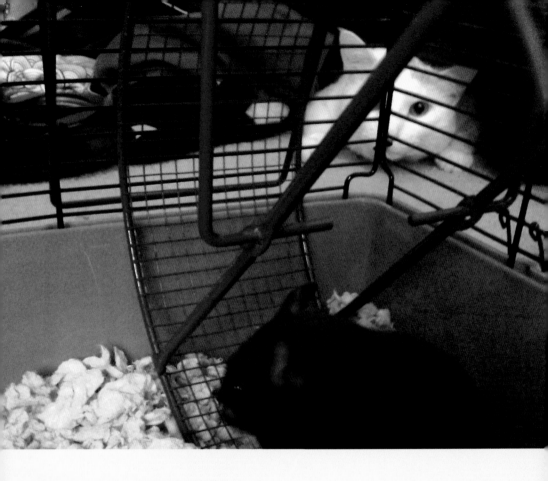

Leave that hamster alone, cat. You'll spoil your dinner.

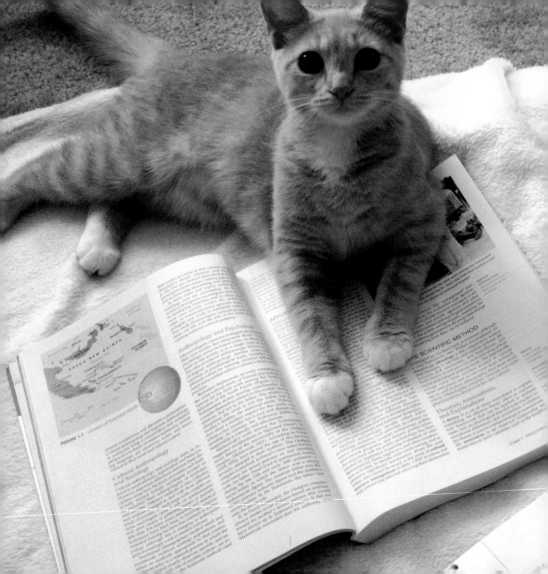

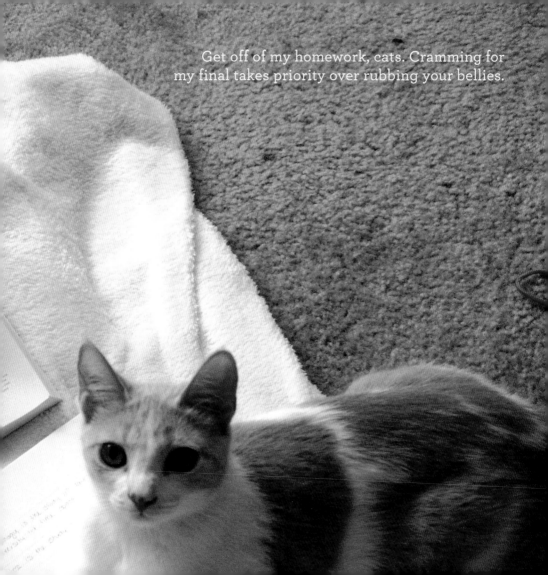

Get off of my homework, cats. Cramming for my final takes priority over rubbing your bellies.

"HELPING"
(THIS MIGHT WORK BETTER IF YOU HAD OPPOSABLE THUMBS.)

Maybe we've got it all wrong. Maybe when our cats are sleeping on our laundry, they aren't trying to get it dirty again; they just want to warm up our socks before we put them on. That annoying thing they do when they knead your trachea? I'm sure they just want to try their hand, er, paw, at reflexology. Or perhaps their forays into our kitchen cabinets are actually attempts to locate that pot lid we've been missing for months—but I doubt it.

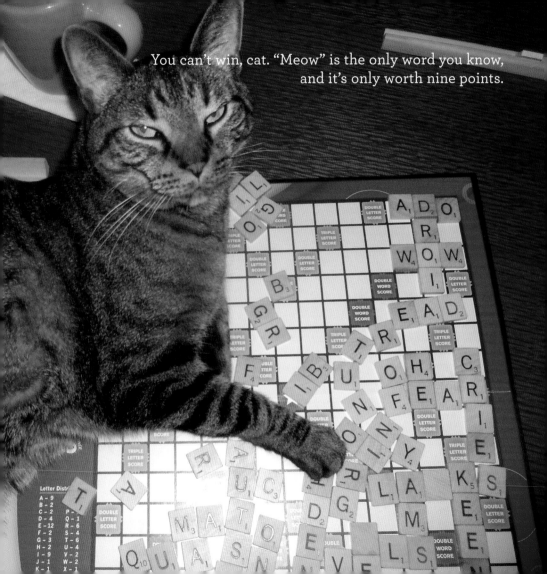
You can't win, cat. "Meow" is the only word you know,
and it's only worth nine points.

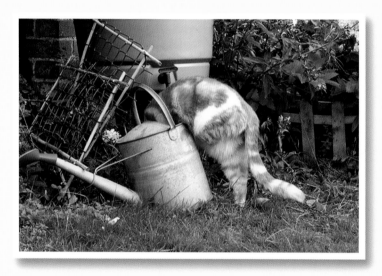

Get out of there, cat.
There are much easier ways to get a drink.

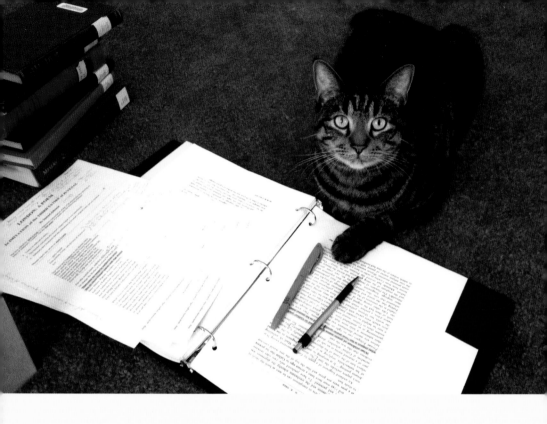

No, I do not want "feedback" from you about my thesis, cat.
I refuse to take suggestions from someone who leaves fur balls
in my living room.

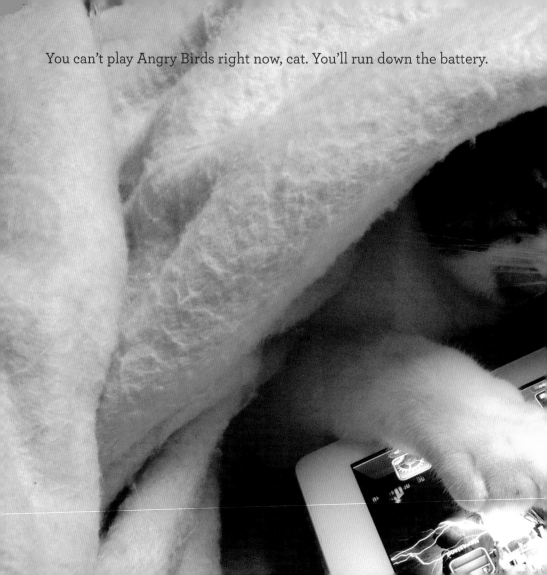

You can't play Angry Birds right now, cat. You'll run down the battery.

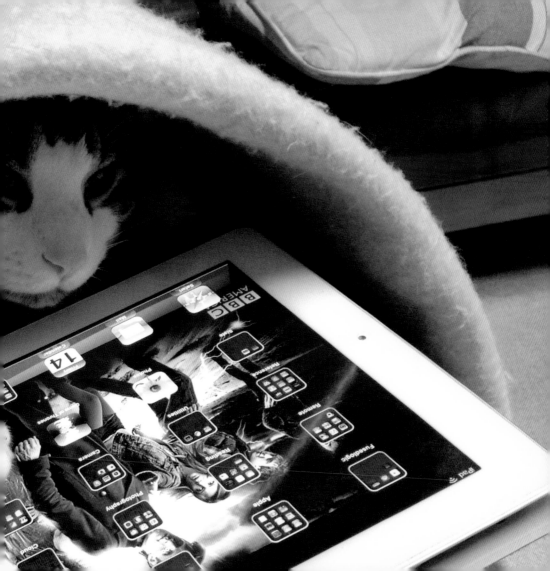

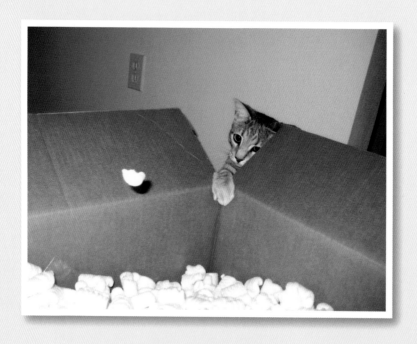

Don't climb in there, cat. Not unless you want
a lesson in embarrassment from Professor Static Electricity.

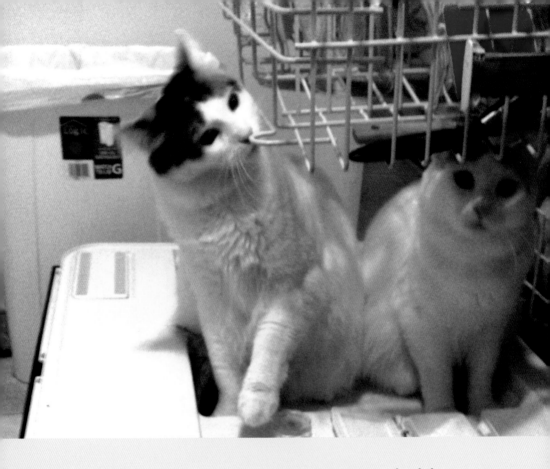

Run away, cats. You both hate water,
and the dishwasher is its evil secret headquarters.

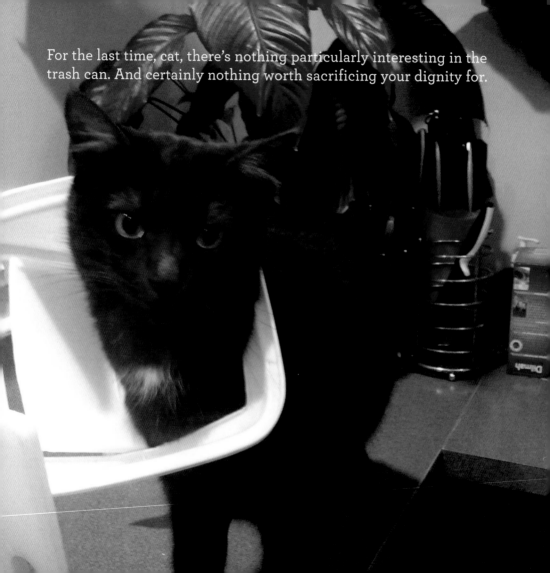

For the last time, cat, there's nothing particularly interesting in the trash can. And certainly nothing worth sacrificing your dignity for.

Get out of there, cat. I already know you're special.
You don't have to find new ways to prove the point.

The line between heroism and
foolishness is very thin, cat. And you're about to cross it.

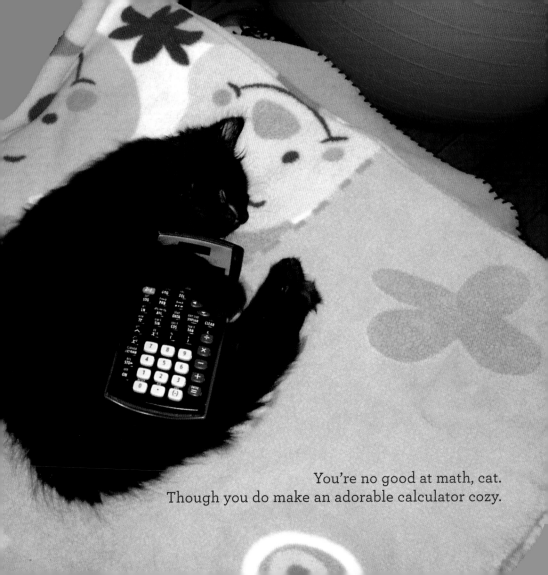

You're no good at math, cat.
Though you do make an adorable calculator cozy.

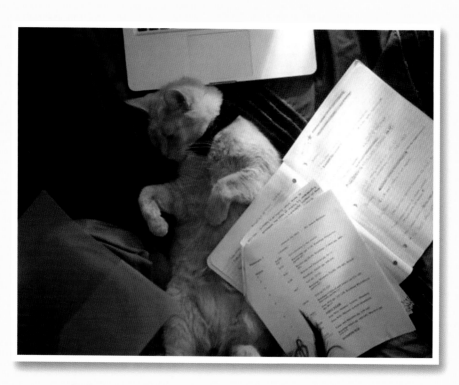

You can't help me with my homework, cat.
All you can do is help get hair on it.

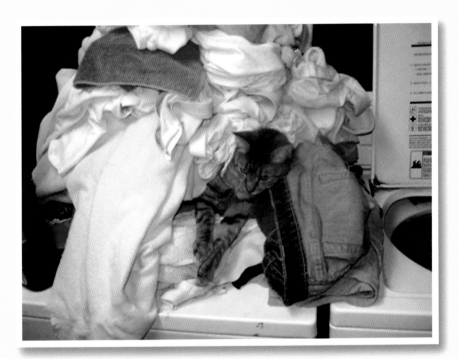

Quit hiding in the dirty clothes, cat.
For the last time, I'm not putting you in the washer.
Your spots aren't supposed to come out.

THE BOTTOMLESS PIT
(SO IT'S YOUR STOMACH THAT I KEEP THROWING MY MONEY INTO?)

If there's one thing cats love more than sleeping and getting chin rubs, it's food. Ever woken up to find the cat food bag spilled on the kitchen floor? Check. How about the dog food bag? Check. Uncooked pasta? Check. It doesn't really matter to cats whether or not they're going to actually eat it, they just want to sample everything and anything in our homes that may or may not be edible. Just as long as she doesn't try to lick my face when she's done tasting the dishwasher!

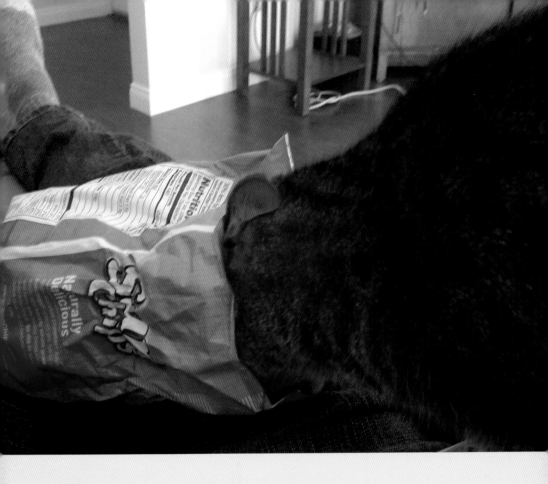

Don't eat all the chips, cat. Save some for me.

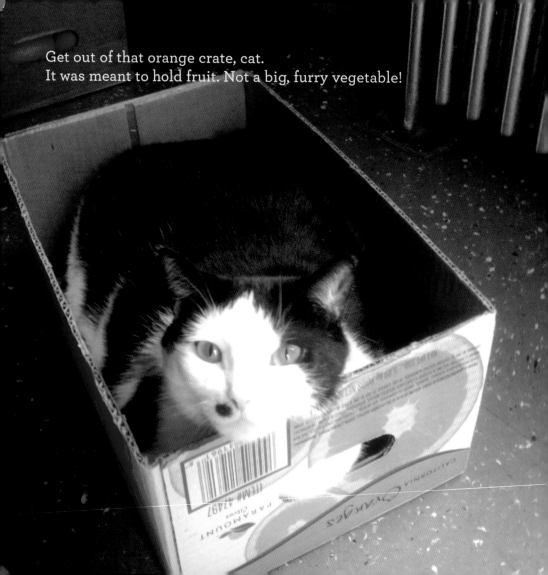

Get out of that orange crate, cat.
It was meant to hold fruit. Not a big, furry vegetable!

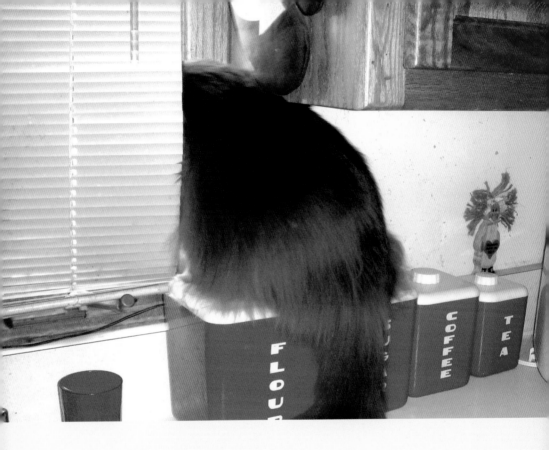

Quit looking out the window so expectantly, cat. I told you already that the pizza guy isn't coming. It's leftovers again tonight.

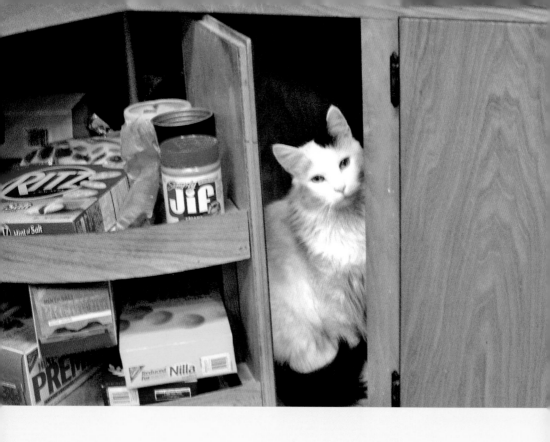

No, cat, I won't call your secret napping spot your "lair."
Mountain lions and leopards have lairs. Domestic felines who won't
go outdoors if there's too much dew on the grass have "nooks."

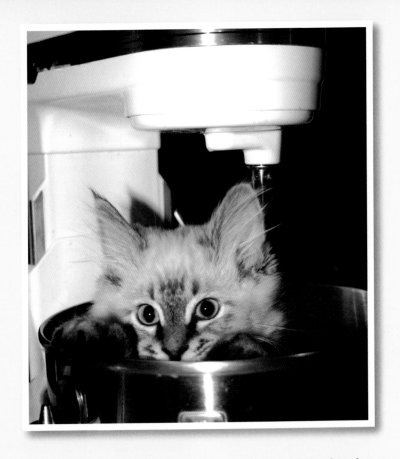

Get out of the kitchen, cat.
The only thing you know how to make is trouble.

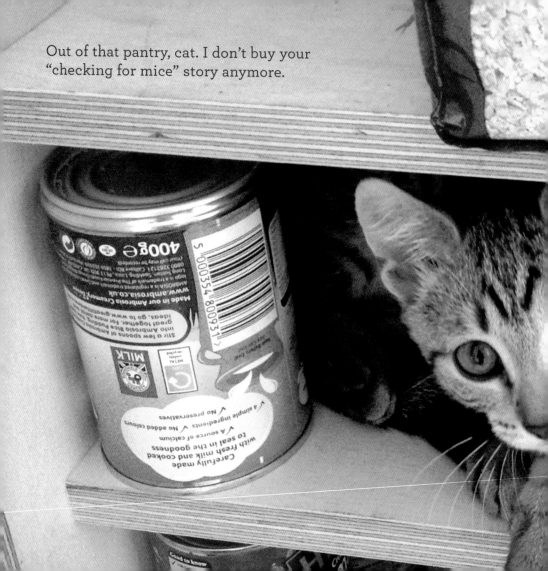

Out of that pantry, cat. I don't buy your "checking for mice" story anymore.

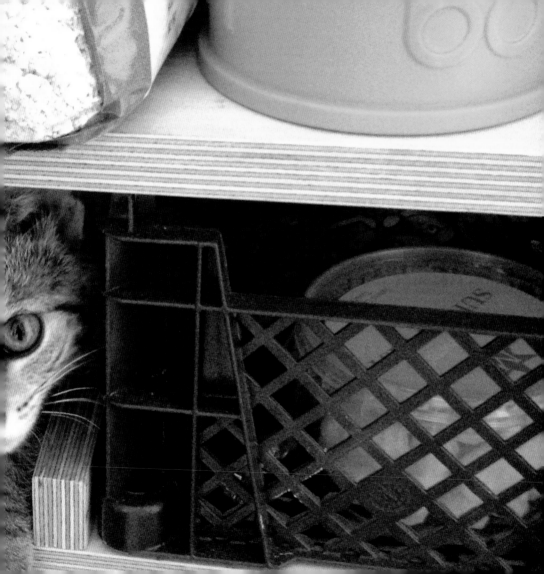

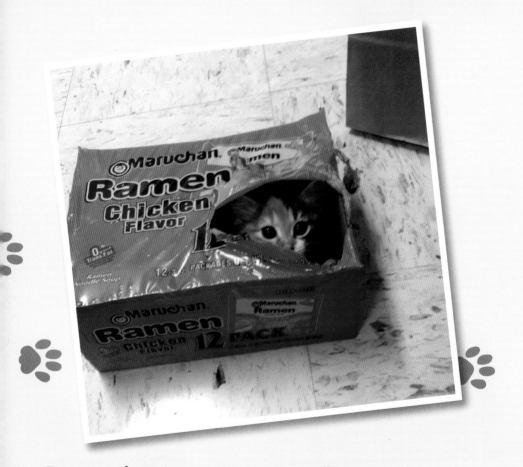

Ease up on the Ramen, cat. You're not in college anymore.

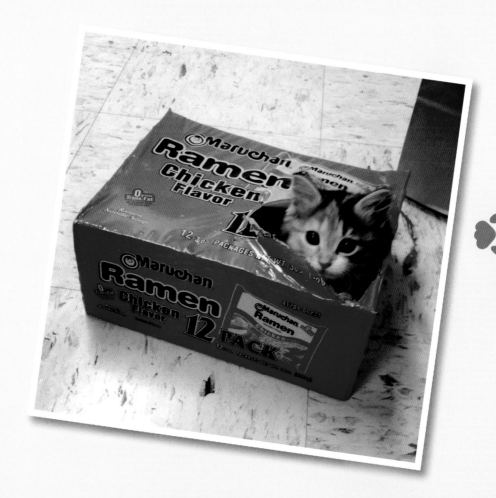

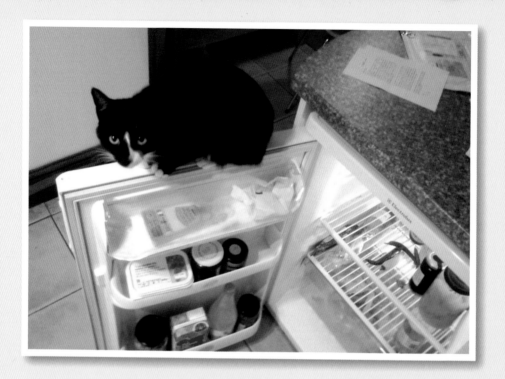

Leave the refrigerator alone, cat. You can manage the door, but you can't wield a can opener to open your cat food. Go back to sleeping in the sun, and let your human servants attend to your needs.

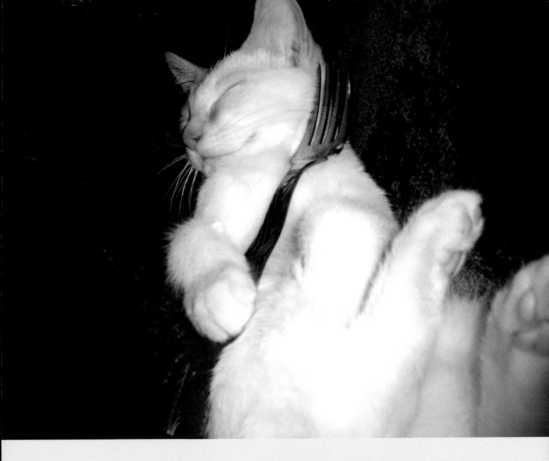

Greedy cat. So that's how you raid
the chicken salad without smearing it all over your face.

CONTRIBUTORS

Front cover photo: © Rachael McKenna / Image Source

Back cover photo: caitlin schaffer

Page 7: karen kawa/tom loaf; page 8: stephanie romm/milo; page 9: chloe holloway/vera; page 10: taylor schlegel; page 11: aaron witham/pickles; pages 12-13: james furnival/ole; page 14: lisha tignor/coheed; page 15: haley lynn churchill/murry; pages 16-17: brent murray/buddha; page 18: taylor schlegel; page 19: ivo vermuelen/isis; page 21: rebekah bell/rosie; page 22: amaira gallagher/penny; page 23: andrea gray/kit; page 24: jacki wilson; page 25: jessica ward/mini; page 26: louisa taylor/maisy; page 27: taylor peterson/zoa; page 28: sara martinovich/billy mays; page 29: keely penauler/henry; page 30: lynne locke/pearl; page 31: katherine burke; page 32: zoltan kormeni/maru; page 33: nikki gray/louise; page 35: kate stewart; page 36: lindsey schmidt; page 37: celia anne/gus; page 38: desiree perez; page 39: savanna hermes/fatty; page 40: jazz truskowski/momo; page 41: jasmine middleton/clary; page 42: aaron witham/pickles; page 43: christina witt/roxie; page 44: kelly mcduff/ganymede; page 45: laura feeney; page 46: kaytie everett; page 47: melanie sweet/lexi; page 48: christina witt/roxie; page 51: lucy haugh/ramone; page 52: laura parrott/madina; page 53: kelly mcduff/ganymede; page 54: sara martinovich/billy mays; page 55: peter gordon oakeshott; page 56: caitlin mcelroy; page 57: katie frantz/coco; page 58: rob harrington/lily; page 59: kristine vandenburg/freddie mercury; page 60: sheila ogden/neville; page 63: anna kaskanlian/cleo; page 64: carsyn scott/fuzz; page 65: jasmine floyd; page 66: rachna pandey/bing; page 67: courtney sherrin/jaspurr; page 68: savannah desormeaux/shmo; page 69: jayde feliner; page 70: ben sears/merlin; page 71: aaron fredricks; page 72: amanda m/amelie; page 73: chris knapp/tubby; page 74: cassian lodge/rosa; page 75: amanda moraes/boris; page 76: susie connor/gavin; page 79: amy kasten/brody; page 80: robyn roth/little buddy; page 81: elizabeth hagen/snowball; page 82: kelly christensen/bubble tea; page 83: kathy

whittaker/efrem; page 84: rebekah van lare (right) and katie long (left); page 85: brigette burkhardt/toby (left) and marina winterman/winry (right); page 86: chris knapp/peanut; page 87: amanda moraes/felicja; page 88: bre roz/lincoln; page 89: jodi jones/killian; page 91: chloe holloway/vera; page 92: heather knapp/leo; page 93: mandy quinn/loki; page 94: kristina knapp/ruby; page 96: raquel mcdonald/georgia; page 97: tessa buchanan/rosie; page 98: chloe holloway; page 99: vivien ilett/mochi; page 100: rebeca paterson; page 101: lauren hirsch/callie; page 103: leah mains/snowball; page 104: diana pietrzyk/casey & chancho; page 105: chelsea wan/kiko; page 106: pakapreud khumwan/google & sap; page 107: sarah adams/maggie & casanova; page 108: dave lehl/yuki & harold; page 109: katie tice/harold; page 110: taylor schlegel; page 111: celeste zanabria/coco; page 112: shelby butler; page 115: anna mccormally/baby kitty; page 116: eleanor russell/mccarthy; page 117: kellie smith/bailey; page 118: evan adnams; page 120: stephanie colby/lilo; page 121: tugce tuncay/shirin & sherbert; page 122: dave agnew/mini; page 123: amy kasten/max; page 124: aubrie scott/doorstop; page 125: meaghan sebeika/lilly; page 126: leila ryndak; page 127: abby p/chaos; page 129: greg larson; page 130: christina hawkes/prawn salad; page 131: patty murphy medlin/robert; page 132: angela lee/casper todd; page 133: erica knight/butters; page 134: chloe nagle/miaow; pages 136-37: caitlin schaffer; page 138: tristan rogers/tinker; page 139: raquel mcdonald/lucien

ACKNOWLEDGMENTS

To Aubrie Scott, for your assistance in running and maintaining the blog, as well as putting up with me when I fall over squealing at a particularly adorable submission.

To Chris Knapp, for putting up with me in general, and being my business assistant and proofreader throughout this entire process.

To Sam Stall, for your assistance in writing the wonderful captions for this publication.

To Brandi Bowles, for your professional advice for me in this process and helping me navigate this new territory.

To Jordana Tusman, for your patience, professionalism, and attention to areas I never would have thought of to make this book the best it can be.